Strange Beauty

Strange Beauty
by
David Cycleback

Hamerweit Books
ISBN: 978-1-312-33523-3
© 2014 David Rudd Cycleback

Image credits:
Cover: Cropped version of 'White rat at the temple of Karni Mata' by Avinashamaura, Wikipedia.org
Squirrel: William Sutherland, Wikipedia
License: http://creativecommons.org/licenses/by-sa/3.0/

Most people are other people. Their thoughts are someone else's opinions, their lives a mimicry, their passions a quotation.
    -- Oscar Wilde

The object of art is to give life a shape.
    –      – Jean Anouilh

# ( 1 )

Did you know cheetahs are the only cat without retractive claws?

\* \* \* \*

US Civil War Union General William T. Sherman's military philosophy was he hated war and battle-- he had seen too many young men killed--, but felt that if you had to wage battle you fought to win, no compromises. He thought that playing it safe and trying to minimize bad things only served to make the pain of battle worse. He is considered one of the most ruthless, brutal and effective generals in history, the originator of modern warfare and scorched earth techniques.

\* \* \* \*

The key is to lie so often they don't know when you tell the truth.

\* \* \* \*

People process information psychologically. They judge information aesthetically. Aesthetics is a primitive biological identification tool.

\* \* \* \*

Studying aesthetic perception as it applies to the art, physical and mental worlds shows us that there are inherent limitations to human perception, knowledge and understanding of the universe and the

things in it. Our perception, judgment and thought are formed through inborn and learned biases, taste, arbitrariness, subjectivity, education and personal experiences. Even our senses involve illusion, physical limitations and unsolvable errors. Just as art involves fiction and fantasy, so does our perception of the universe and the physical world around us.

\* \* \* \*

A Discharge song hits all the notes. I mean that literally. Sometimes simultaneously.

\* \* \* \*

In art, people tend to like meaning that is implied rather than explicitly spelled out. A movie that makes obvious or beats you over the head with its point is critically downgraded, even if the point is considered valid. A joke is deemed a failure when the teller explains the meaning. Why do you think this is?

\* \* \* \*

Henry: "I get my news from People magazine."
"I get mine from CNN.com"
Henry: "That's what I meant."

\* \* \* \*

Neuroaesthetics is the name for the scientific study of aesthetic perception, and involves neuroscientists, biologists, psychologists and others. Many scientists are skeptical of the field--- or at least of getting concrete answers--, because sublime, beauty and ugliness are subjective and can't be objectively identified or measured. Many artists and art lovers dislike the scientific study of art perception because they feel the knowledge ruins the mystery important to art.

\* \* \* \*

One of the assumptions people have for art is that there is a meaning, just as many people assume (or, rather, hope-assume) there is meaning and order to the universe. Even when they know they don't know what is the meaning and order they automatically assume they are there.

\* \* \* \*

People say "Public nudity is completely inappropriate. Except in your case, David."

\* \* \* \*

Henry: "The difference between me and know-it-alls is I actually know it all."
"If you know it all, then what's my favorite color?"
Henry: "Black. Black as the Devil's heart. Black as the murderer's soul. Black as the bottomless pit of depravity that is your life."
"Okay, but that one was easy. What's my favorite vegetable?"

"Ha! It's the cucumber!"

\* \* \* \*

**Did you know?**
Sculpture is often a commentary on or response to previous sculpture, so to understand sculpture one has to know the history.

\* \* \* \*

Explain how art would be different if humans had the night vision of owls or the senses of bats?

\* \* \* \*

I remember as a kid listening for the first time to a Haydn piece and being disappointed in the composer as the piece lifted a melody from a Mozart piece I'd often heard before. After looking into it, I learned that the Haydn piece had been composed first and Mozart lifted from Haydn.

\* \* \* \*

Communication in art and literature is a curious thing, because the writer has ideas and ways of thinking and communicating and the reader has ideas and ways of thinking and communicating. Different readers have different ways. The art is a language that is often read similarly and often read differently. It makes direct communication between reader and author impossible, but many people say the beauty of art is that readers read it in their own way, get their own personalized message. And a reader can indeed have different and valid insight on a subject, see the biases and ignorance of an old writer. This is part how art can be timeless.

And many artists don't try to communicate one to one, but offer something where the readers will read it in their own way, take what they can take from it. And people who dismiss or dislike an artwork for its style are reading it in their own personal style.

\* \* \* \*

\* \* \* \*

"What is it like having such a smart kid in your family?"

\* \* \* \*

People process and judge information, even random information, by their habitual rules, because that's the only way they know how to interpret it.
    Sort of reminds me of the old joke about the guy on his hands and knees at night looking for his car keys two blocks away from

where he dropped them because the light where he is looking is better.

\* \* \* \*

I've been to Hell once, for a moment, while I was sick and half asleep on the couch on an afternoon.

\* \* \* \*

"How you get this idea that you're so great?"
"Because I compare myself to others."

\* \* \* \*

And I try make this into a book, give it some physical bulk. Really, I could write it into two pages but who would pay money for that?
    Actually, I couldn't write it in a million pages

\* \* \* \*

I'm well aware you're not supposed to say 'Actually'  Get off my back, I already have a mother.

\* \* \* \*

When humans listen to music, they automatically get a visual image in their minds-- a scene, story, person, landscape, animals, dreamlike design, musicians playing, other.  Humans are visual animals and this is how they 'hear.'  You never process or listen to sounds on a purely auditory level.

\* \* \* \*

There's such a shallow pressure that everything in a book has to be imbedded with art and meaning, that words have to be written in a

poetic turn. It's a conceit, a fashion. I sometimes don't want to write that way or feel a need to write that way, or even feel it relevant to the subject or to anything. *The gas station is on the second left* versus *Take the second left*, whatever.

* * * *

Simple cadence is a major part of communication and people extract meaning from cadence. Stutter step and you throw people for a loop. They'll be insulted by the most benign statement about a small piece of fluff.

* * * *

What exactly was Godzilla? He was a T-Rex that was hit by an atomic bomb.

* * * *

In a work of art you're suppose to imply what you are saying rather than overtly saying it, so I overtly say it.
  But I also know if you say things straight it will leave out lots. There are things that can only be said in music and art and angst and emotion. Some things can only be implied, said subconsciously.

* * * *

Breaking aesthetic rules gives insight into small mindedness of the reader, though the small minded reader doesn't see it that way.

* * * *

Perfection is countless things as one thing, including water and oil made one. The closest I can come is through carpet bombing. Hitting all the points at least once and hoping for something special in the deafening noise.

\* \* \* \*

To humans, the meaning of life, of everything, is mood.

\* \* \* \*

"The heart wants what the heart wants."

\* \* \* \*

the entering into art scene with the Ligeti piece-- slowly going over alka seltzer as in taxi driver. Maybe this can be shown in photos. Think about this, work on later.

\* \* \* \*

I want all the scenes to take place at night, with night logic, dream plottig, spaces between scenes. Add night photos.

\* \* \* \*

Sometimes there is an otherness, a foreignness, to my thoughts, at the fundamental atomic level, and I only get through the day by habit and muscle memory. People around me during the day won't even notice anything different.

\* \* \* \*

Did you know? Anne Frank went to correspondence school while hiding out. Her family had locals smuggle in and out food, letters and her homework and tests. She took the courses under one of the local helper's name.

\* \* \* \*

I've learned that the desire for perfection and symmetry and porcelain beauty, and more important the idea that truth lies in these things, is a sign of immaturity common to humans. Those who criticize this for the usual literary reasons are myopic crowd followers, and the rest who don't understand are just plain dumb.

If it's for entertainment purposes, okay. But, for God's sake, don't take yourself so seriously, it's embarrassing. If you insist on clinging to your cognitive biases, the kids' table is over there.

\* \* \* \*

Aesthetically I don't like the previous piece-- re-reading it just didn't come across well. And some of the wording is muddy. Which is why I left it in and left it in as is
And in fact this right here seems a little too, a little too ... I don't know. Pre planned or cute or something. But that's all aesthetics which is neither here nor there, but clearly I'm not immune to aesthtic tasate
If I was trying to be aesthetically pleasing I'd cut out the previous and this piece but I have grown some cajones since the last book. Some.

\* \* \* \*

"Saying you once returned a library book late doesn't count as a deep dark secret from your past."

Henry: "Sorry, that's the best I can come up with. I've led a wholesome life."

"If I'd have known that would have been your answer, I wouldn't have gone first and detailed my decade long cross country killing spree."

Henry: "Next time we can flip a coin."

\* \* \* \*

Henry: "That was a long time ago. How do you know God hasn't changed his mind since then?"

\* \* \* \*

William Faulkner said he read all the books he could get his hands to learn how not to write.

\* \* \* \*

And if the text is lazy and uninteresting and apathetic, that's a statement. Boredom and not caring and being lazy is a statement. The necessity of passion is a fashion. People who say art should be made with a passion in the subject have already started with a predilection and are looking for something other than the truth. Who says truth can't be found in apathy? It's often the lazy who see the forest and the trees and those who can't wait to get to work who forget their keys and wallet.

\* \* \* \*

This book is the product of genius but most people doesn't have the tools to understand it.
    Just so you know.

\* \* \* \*

Actually, true works of genius can't be understood by anyone, including often the inventor. Just ask Bela Lugosi in one of his movies.

\* \* \* \*

I'm not sure if that last one made sense, but I'll leave it.

\* \* \* \*

I prefer making a document than a work of art. A document means you leave in the things that would be taken out of art. The mistakes, the reality, the awkwardness, the cheesiness.

Even a failed attempt at art is good as a document, gives you meaning beyond the text. In that sense, a work of art is a failure.

Any work that has edited out the cheesiness is a lie. We're all cheesy at times, in real life tell jokes that bomb. A document leaves them in

\* \* \* \*

If you believe in God why do you think he gave humans aspirations they cannot fulfill, questions they are unable to answer?

\* \* \* \*

I believe humans want a perfection that cannot be achieved and may not exist. Perfection may just be a human idea, and the human idea of what is perfection most certainly is. And readers are looking for it in this book as they look for it everywhere. You see it in their criticism. And I know it cannot be achieved and I know the readers are wrong for looking for it, so defy, rebel against it, complain against it and against the readers, but also try to create a conglomeration, a collage, a mess, that approaches it in a way. I do want to create a music. And I do at times, in ways. The sublime moments found in disjointedness, rebelliousness, broken music, messiness, discord, carpet bombing.

\* \* \* \*

Some of the things I write are real while others are not. Part of the intent is for the readers to be unable to tell which is which. Though I'm sometimes curious if discerning readers can tell. I sometimes wonder if I'm more obvious than I think. To try to prevent this I mess things up more. Shift the the sands.

\* \* \* \*

"Nice thing about pancakes is if you accidentally step on them they're waffles."
Henry: "Don't step on my pancakes."

\* \* \* \*

\* \* \* \*

Henry: "I hate fad whores, posers, serial bandwagon jumpers. I won't do anything that others do."

"What about breathing?"

Henry: "I taught myself to breath out of my ears just so no one could accuse me of being a crowd follower."

\* \* \* \*

Henry: "Why do you always smirk in your photos?"

"A woman said my smirk is sexy and my smile is sweet, and I prefer sexy."

"Actually, when I grin in photos I always fear I look like an actor pushing a product in a television ad. We former teenage shoe gazers naturally cringe at the thought of that."

\* \* \* \*

I've realized that Sunn 0))) essentially is Discharge played backwards and 20X slower. In other words, Discharge is the nuclear apocalypse while Sunn 0))) is the nuclear apocalypse in an altered state.

These things come to you as epiphanies afters hundreds of hours of listening at full volume.

\* \* \* \*

It never leaves you. At some point in the future it's crystal clear in your head again.

\* \* \* \*

A big mistake, and I suspect a mistake many people make, is to think this book is about one thing, even when I specifically spell out the philosophy of the book. I'm well aware that readers will take one point they think they understand and apply it as a broad brush to everything else, as if the book is a Agatha Christie murder mystery with one final who dunnit answer.

And there also is one answer and I spell it out.

\* \* \* \*

Most critiquing is trying to force a work into the critic's pet form and shape. The corners of a square peg rhetorically lopped off to make it fit the critic's preferred round hole.

One of my favorite stories is about *Avalon,* Barry Levinson's well regarded 1990 movie about a Polish-Jewish immigrant family's experiences in their new home of America. Responding to a critic who downgraded the movie because it didn't detail the characters' previous lives back in Europe, Levinson said "But that's not what that the movie is about."

\* \* \* \*

"Now that George Clooney is taken, I guess that makes me the most eligible bachelor."

Henry: "I guess."

\* \* \* \*

Henry: "To tell you the truth, David really is a polymath as he claims. Except everything he knows about is incredibly boring."

Henry: "I mean if you accept an invitation to coffee with someone who wrote a history of numeral systems, that's your choice of poison. He leaves me alone because he knows I bite."

\* \* \* \*

Did you know? The Three Stooges really were stooges. In old Vaudeville a stooge was a term for a lower level comedian who supported the star, and Moe, Shemp and Larry started at as a trio of stooges. And in their later movie shorts their recurring supporting actors were their stooges.

\* \* \* \*

Henry: "That's the worst coffee I've ever tasted."
David: "It's paint."
Henry: "Not bad then."

\* \* \* \*

Always remember that your taste in art and your philosophy and critiques of art, along with your political, social and religious philosophies, are products of your personality and temperament.

\* \* \* \*

"Why do you leave your back door open in the middle of the night?"
"Enter the back door in the middle of the night and find out."

\* \* \* \*

Henry: "I wondered why it was metallic blue."

\* \* \* \*

I was told people like pictures.

\* \* \* \*

"No, the semicolon was intentional. I put it in there to flush out all the anal retentives."

\* \* \* \*

A Mexican-American woman from Los Angeles and I were talking about our ethnic backgrounds. I told her I was the descendent of Vikings and she was impressed and said that was so exotic. As a pasty boy from Wisconsin, I'd never before been called exotic.

# ( 2 )
# Basic qualities that evoke aesthetic reactions

Which design pleases your senses more? Which is calm and serene and which is loud and noisy? Your picks are natural.

Using brain scans, neuroscientists such as Semi Zeki of University College London and Vilayanur S. Ramachandran of University of California at San Diego have shown that much of our aesthetic perception of art is natural emotional reaction to basic sensory stimuli. Whether viewed on their own or incorporated into art or the physical world, many simple, basic qualities and designs evoke natural psychological, aesthetic and even physical reactions in humans. Many of the here come from the work of Zeki and Ramachandran.

The reactions we have to certain colors, angles and textures are in part hard wired into our brains, though can be honed and altered with experience, education and culture. Artists use these emotion inducing qualities to help express their artistic ideas and create aesthetic feelings. A landscape painter may use warm colors and soft lines to evoke pleasant and serene reactions, while an

advertising poster artist or propagandist may use bold colors and jagged lines to excite the senses and raise the blood pressure.

The following looks at just several of these qualities and our responses. When you think about them you will realize that many of these reactions have practical uses, uses that helped us survive as a species and live efficient lives today.

**Symmetry and Balance**

Humans are naturally attracted to symmetrical and balanced scenes in nature and designs in art. We judge the health and beauty of other humans by symmetry. The standard beautiful face and healthy young body is symmetrical. On the flip side, someone with a hunchback, limp or disfigured limb is seen as injured or diseased. A flower that is wilted or a tree that is shifted to one side is seen as dying or sick.

Artists commonly use symmetry and balance to depict beauty and elicit a pleasurable, serene response in viewers. An artist who wants to express disorder, violence and chaos may remove symmetry and balance. He may leave things out of place, make things crooked and messy. Movie monsters are commonly depicted as deformed and unbalanced. Zombies drag limbs. Humans get a negative visceral reaction from this.

This hard wired attraction to symmetry and visceral distaste of out of balance was important to our survival as a species, as mating with youthful healthy people and raising healthy crops helped ensure the survival of the species.

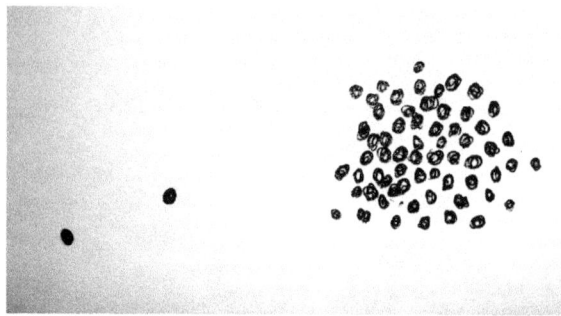

**Out of place.** Both in art and in the physical world, and even on the dining room table, humans automatically notice things that are out of place. Many people have a distaste for seemingly out of place things, such as the fork out of alignment with the spoon, knife and napkin. This not only catches our attention in art, but is necessary for our survival as a species. Our ancient in the wild selves wouldn't have survived long if they didn't notice things abnormal or seemingly out of place.

If you ask kids, they can make up a story about what is going along with the previous dots. They may say the two dots are rebels shunned by the groups, or they may say they are trying to catch up with the group. To many, these dots are telling a story, even if they are not sure what is the story.

**Mysteries and solving mysteries**
Humans are distressed and intrigued by ambiguous scenes, juxtaposition of seeming unrelated things, mysteries and puzzles in art and in the physical world. Our blood pressures raise and our attention is drawn. This initial psychological response towards mysteries, as is often used in art, is natural. As is the following trying to figure out what is the meaning in the mysteries and what is the relationship between and larger meaning in the juxtaposed objects. Emotionally responding to then feeling psychologically and

intellectually compelled to solve mysteries is natural to humans, as is the pleasurable response we get when we feel we've solved the mystery. There's a reason why so many people get enjoyment out of television mysteries, jigsaw and crossword puzzles and magic eye pictures-- at least when, in the end, the mystery is solved, or the puzzle finished. If the puzzle is never finished, or the who done it in the Murder She Wrote is not given or is otherwise unsatisfactory ('That was so contrived with so many illogical plot turns and missing details that no one in the audience could have figured it out. In a proper mystery, the audience has to at least have a chance to logically figure it out.'), then the emotional response naturally is not pleasurable.

This mystery and mystery solving applies to still art, including paintings and photographs. People naturally ponder what is going on, try to solve the puzzle, figure out what the people in the scene are doing and thinking, who they are, what is the overall meaning.

This all mirrors our ancient days when humans in the wild were at first distressed or intrigued by a mystery then glad when it was solved. Solving or at least reacting to such mysteries was essential to survival.

In fact, humans enjoy solving a mystery more than knowing the answer right away. The final pleasure is heightened when it is preceded by mystery and mental problem solving effort.

**Contrast**
Related to mystery and identification, people naturally like good contrast and have a negative or intrigued reaction to lack of contrast. This is because good contrast means we can identify things, and bad contrast makes identification and distinction harder to impossible. Fog and dark obscure or hide identity and blur the lines between different objects. There is a reason that murder mysteries and horror movies often involve fog and dark. The hidden and obscured scares us, literally raises our blood pressures. When the fog or dark is removed and a harmless scene is revealed, there is a pleasing, relaxing reaction.

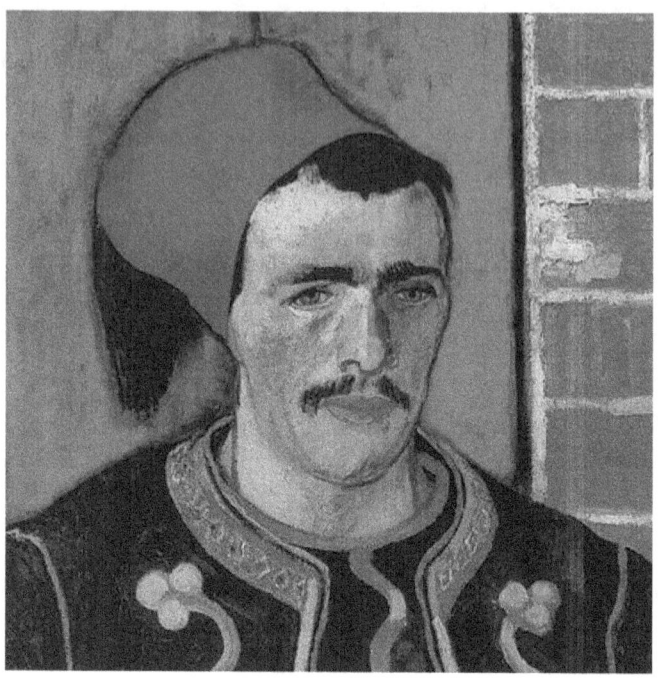

Humans naturally like the bold if unrealistic outlines, such as in this Van Gogh painting, because it gives distinct contrast.

## Meaning and Identification

People naturally like scenes, situations and art where they know what is the meaning and identity, as opposed to where the meaning (if there is one) is a complete mystery. People often have viscerally negative reactions to abstract art, because they don't understand it. They don't know what it is supposed to mean, they don't see identifiable objects. They want it to be like 'normal' art where there is an obvious boat or a house or animal or mountains.

People who are artists or otherwise more educated about art, tend to like abstract art more, because they understand it more. They understand that art and design can communicate on an emotional rather than literal level. With more exposure and longer viewing of

an abstract painting, people tend to like the painting more. It's their initial, gut reaction that is most negative and visceral.

This is a natural reaction in humans throughout our history, as all humans have never liked, or at least are highly intrigued, when faced with a situation where they have no idea what is going on. They want concrete answers and identities. It's important to survival.

**Unrealistic exaggerations**
Professor Ramachandran says that humans are psychologically influenced by unrealistic exaggerations of certain qualities. Take size as one example. To humans, the larger the wolf or alligator or gorilla or bear or mountain, the more intimidating and awesome. The larger man is assumed to be the more powerful than the smaller one. Logically, you know you will likely someday see a house and bear and spider bigger than you've seen before. This mindset extends beyond the bounds of reality. In the extremes, we get impossible super powerful and super sized characters such as Hercules, Superman and the Incredible Hulk. If a gorilla is intimidating due to its size and strength, then King Kong is that much more intimidating.

This helps explain our psychological reactions to the exaggerated in art, dreams and day dreams.

**Identifying objects through basic qualities**
Professor Zeki says humans naturally identify objects by basic, essential qualities. As objects such as trees, apples and dogs each vary to degree from specimen to specimen (two apples will differ in tone, shape and/or size), we must be able to identify them by these basic qualities, such as general color, general shape, general size and weight. Many artists reduce the subjects of their art into the bare essentials that allow the viewers to recognize what they are. The ability to identify objects by general key qualities is essential to our survival since our ancient days, as bananas, for example, don't come in the exact same sizes, shapes and tones and we need to identify what objects are edible.

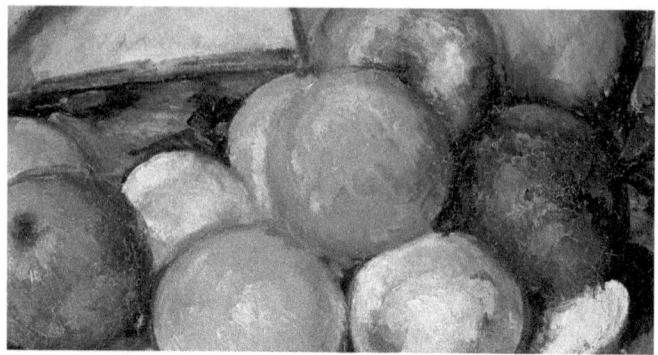

Most people identify this detail from a Paul Cezanne painting as fruit.

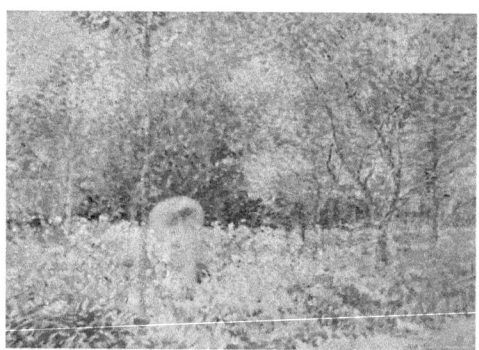

Impressionism, such as this 1913 painting The Parasol by Karl Albert Buerhr, tried to show how light played on objects and how the human eye naturally saw things. We recognize it as a person in a wooded and bushes area.

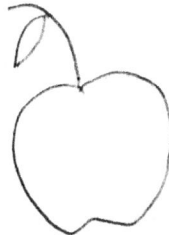

An apple, of course. Notice that many symbols use the bare essentials of what they symbolize. Blue for sky or water, black for night, stick figure with stick arms and legs for human, :) for happy.

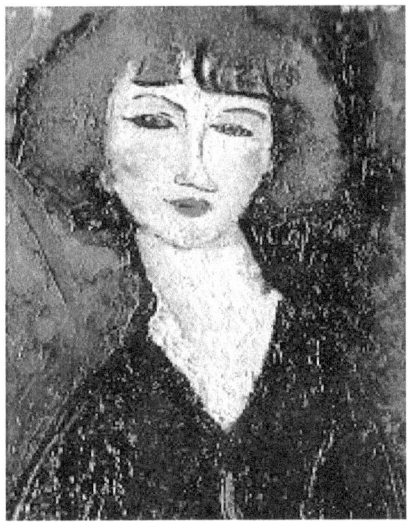

Amedeo Modigliani painting that we perceive of as a woman

## The strange and new

Things that are brand new and strange to your eyes, such as an albino squirrel in your back yard or a bizarre animal at the zoo, catch your attention and imagination and literally raise your blood pressure. This response is important as our current and ancient

caveman selves wouldn't have survived long if they didn't notice and ponder about new and strange things. Artists regularly use bold radical designs, odd objects, strange juxtapositions to catch the imagination of viewers and focus attention. Experiencing the new is often a major part of experiencing the sublime.

Of course, new and strange is relative. A plant rare and exotic in Oslo may be a common weed in Nebraska.

**Colors**

Humans have psychological reactions to colors, both due to nature and culture. Bright red and yellow naturally stimulate the senses and raise blood pressure, while blue is calming. Brown is earthy in both the figurative and sometimes literal sense, while green is naturally and culturally associated with nature.

People have naturally favorite colors. It is often inborn. Someone may not know why blue is his favorite color, he just knows that it is. The color is pleasing over other colors. He won't know why brown or green isn't his favorite, it just isn't.

Women tend to have better green/red color perception than men, so it should not be of surprise that women more commonly pick green as their favorite color. Green will appear more vibrant to the average woman than the average man.

\* \* \* \*

**Assignments:**

This chapter showed some basic things that evoke natural reactions. Give one or two more examples. They can include variations on the ones mentioned in the chapter or brand new examples.

Find and describe two juxtapositions (you can do an online search) and explain what the juxtapositions signify or symbolize, if just by your personal interpretation.

Symmetry in architecture. People associate symmetry with order and tradition. Some find these qualities aesthetically pleasing while others find them stuffy and too old fashioned.

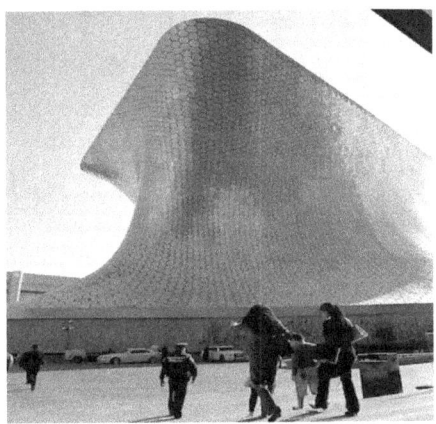

Asymmetry and strangeness in architecture. The unusual, asymmetrical design of Mexico's Museo Soumarya instantly catches the attention of both those who like and dislike it. The unusual design is associated with modernity, invention and cutting edge. It seems like a museum that would hold modern art.

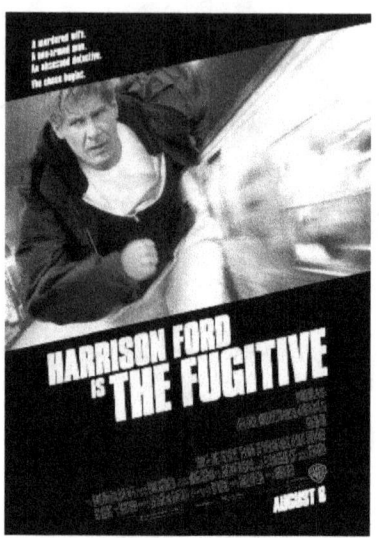

To promote the 1993 action thriller movie *The Fugitive*, the poster designers tilted the image and words, placed the actor off center left and give him an unbalance body position. These things evoke action, movement, danger, a world out of kilter.

Assignment #1: Answer the question What is your personal definition of art?

Assignment #2: Pick two works of art that you love or otherwise find profound and explain why you love them or otherwise find them profound. The reasons can include it is a genre or style you like. It could be due to the size or history. It could be due to what it means, the philosophy. If you connect to a character or it relates to your past, or depicts your home town, explain. If you aren't entirely sure why, say so.

Assignment #3: What widely acclaimed and famous work of art do you not like? Explain why. If it helps, the Mona Lisa doesn't do much for me. And if you pressed me, I might say "I don't know why. It just doesn't. Give me a Botticelli any time."

Just one thing the assignments demonstrate is that you can't fully explain the reasons behind what you like. You can like a work and not be sure why.

## (3)

Humans have vague ideas, psychological inklings, about the mystery of the universe and life that they cannot fully explain. Art can point to these feelings, point to the mysteries of the universe and to ourselves in different ways than other forms of expression. While not solving the major questions, it can perhaps give insight into them, into humans and the human condition of living in a universe where they cannot know the meaning or what is their purpose on earth.

In the end, artworks are artifacts, showing how humans think and perceive, their physiological abilities and limitations, the questions they have, the human condition. Alien scientists from the future would lean about humans from these artifacts.

\* \* \* \*

Idle sidewalk conversation I overheard today between a boy and girl, perhaps about five years old:

boy: "XYZ."
girl (wearing a skirt): "What?"
boy: "XYZ. Examine your zipper. (pointing at her skirt where a pants fly would be)"
(girl looks down at the front of her skirt)
boy: "Ha ha ha! You don't have a zipper!"

Must count as timeless humor as that was a joke when I as five.

\* \* \* \*

Sometimes as a writer, I give up direct communication. I realize that information can't be can't be perfectly communicated and understood by the reader, and give up the ghost and intentionally hide things, make things obscure. I sometimes even point out this is what I'm doing and that ambiguity and obscurity are the very points. Sometimes I write in language and structures that can't be understood and cadence that trips up. Sometimes I write while looking the other way so what comes out is beyond even me and because what comes out can make me wince.

\* \* \* \*

I once told a woman I had mad scientist syndrome and she said "What's that mean?"

\* \* \* \*

There was a period where if I tried to write down something, such as an internet address from the computer screen, it would come out as foreign picture symbols. There was also a time when I was hallucinating that I couldn't tell if my eyes were open or closed, because I saw the same things either way. People thought I was going to sleep when I was awake and I didn't realized I had closed my eyes.

\* \* \* \*

Did you know? James Cagney grew up dirt poor in the mean streets of New York City, while Humphrey Bogart grew up the wealthy and socially elite son of a prominent surgeon.

\* \* \* \*

You'll find that many so-called deep philosophical conundrums are really just superficial word games. If cat was spelled with two t's or an e it would blow up the entire philosophic theory.

\* \* \* \*

"The object of art is to give life a shape."
    You have no idea how much that quote makes me batty. If you love it, I'll knock you about the head, I'll scoff at everything you believe.

\* \* \* \*

A common cognitive bias is believing that if something is natural to humans-- the common perception of what is beautiful, an attraction to symmetry, desire for order, a conception of order, etc--, that's the form of universal truth. Who says truth has to match human biases and predilections? Who says is has to be remotely related?
    I won't repeat all the Psychology 101 that was written on the subject in *Return Trip*.

\* \* \* \*

Yes, I'm very much obsessed about structure, communication, how readers read things. Reader habits, predilections and cognitive fallacies are things that bother me to no end. It doesn't help that I'm a control freak and don't want readers to have their own ideas.

\* \* \* \*

Henry: "Can you help me?"
"What?"
Henry: "I got the #10 megahold hair gel for my new summer look."
"So what's the problem? You look pretty good."
Henry: "I'm stuck to the wall."

\* \* \* \*

Henry: "Is barf an onomatopoeia?"
David: "Depends what you ate."

\* \* \* \*

If it doesn't make sense, I don't care. It's not supposed to make sense. In fact, it makes perfect sense.

\* \* \* \*

Henry: "I'm not saying he wasn't, but it's probably best not to call someone a flaming dipshit."

\* \* \* \*

If you worry about your absent mindfulness, know that Albert Einstein once returned to the library a book containing an uncashed $10,000 check he had used as a bookmark.

\* \* \* \*

* * * *

Art perception, critiquing and judgment are both psychological and intellectual processes, conscious and subconscious, rational and irrational, and we often have conflicting and changing opinions about a work. We naturally get an initial emotional reaction to a work of art-- influenced by our natural and learned reactions to shapes, colors, textures, etc. Our impression of the work can change with time. We consciously try and figure out what is going on, what is the point, how it related to other works. Our appreciation and

liking can change as we learn how it was made, what materials and techniques were used, as we hear others' views and ideas about the work. We can like the artwork on one level but not another. We can appreciate the intellectual point but dislike the aesthetics, or be attracted to the design and colors but find the artist's message trite.

I hate saying there is the heart and the head in art perception because, of course, the 'heart' is the mind. But, if I did, you'd get the point. But I won't.

\* \* \* \*

As I grow older, I don't fear death. I fear losing my mind.

\* \* \* \*

What does it say visa vie defining and identifying art that your enjoyment and appreciation of a work often changes viewing to viewing or listening to listening?

\* \* \* \*

"Why are you still single?"
"All the good ones aren't taken and I prefer a challenge."

\* \* \* \*

Godzilla is a small man in a rubber suit. The surrounding even smaller set and props makes him appear big. If the set and props were many times larger, we'd perceive Godzilla as small as a mouse. Art is illusion and visual art is visual illusion.

\* \* \* \*

Alfred Hitchcock said implied violence were scarier than shown violence and movie goers were more scared in anticipation of a violent event than while the violent event was happening. Martin

Scorsese said what matters in cinema is what is inside the frame and what is outside the frame.

The above paragraph replaces a spelling joke I decided was perhaps too political (even though it was just a joke). They're directors' thoughts from my book on art perception that I still think are good and worthy backup replacements. I nearly added a third quote from Roman Polanski, but figured three would be too many. It was about cinema mentally removing the audience from reality. I've used more words writing about the quote than there were in the quote.

I avoid being political. My grandfather once said, "There are two things you don't talk about in polite company: religion and politics."

Entering into cap anson wood engraving video

Entering roompicture of anson picture on wall entering it closely closely closely at the elbow with autoharp music.

Readers will be taken back by this as it is aesthetically, psychologically evocative, powerful but can't be sure if it's sincere or a cognitive test. This isn't persey my intent, but this is the way it will be viewed. And, of course, why can't it be both, why can't it switch back and forth? Why can't something be both cheesy and heart piercing?

Did you know? In Japanese, a haiku poem is written as a single vertical line. Our three line version is a translation into our Western horizontal writing structure.

\* \* \* \*

Henry: "That movie pierced my soul."
"Dog's don't have have souls."
Henry: "Must have been my liver then."

\* \* \* \*

People critique a work by first deciding what it is-- its identity, meaning, genre, how the pieces fit together, what the artist is trying to say-- then judging that. When someone says a work is trite and dumb, what he is really saying is his interpretation of what it is is trite and dumb.
    I'm not saying the work can't also be trite and dumb.
    Director David Lynch, who never tells his interpretations of his films, said that over the years he'd heard countless different interpretations of his movie Eraserhead, none which matched his.

\* \* \* \*

Telling a human a truth isn't enough. He or she has to be convinced of it psychologically, aesthetically. Humans need to have it explained as a metaphor. Of course, humans often mistake psychology and aesthetics for truth, and metaphor for fact. They take stories literally. Psychology and aesthetics can be another term for smoke and mirrors.

\* \* \* \*

You'll never understand the horror in a cup of coffee

\* \* \* \*

Henry: "Don't interrupt David when he's working on his numeral systems."
"Why? Because he get annoyed?"
Henry: "No, because he'll explain them to you."

\* \* \* \*

I really want my own vision, narrative-- I want to go against aesthetic norms

\* \* \* \*

If I create some magic in my writing, I have to stamp it out. If I create some poetry, I have to mess it up. If I create clear I have to throw some dust on it, mix it up. But you're supposed to find beauty in the dust maybe, the beauty and poignant tragedy in the being all messed up inside.

\* \* \* \*

You'll never understand the horror in a cup of coffee.

\* \* \* \*

As an authentication expert, I can tell you that the majority of counterfeiters aren't trying to fool museum curators and auction house experts. They're trying to find buyers ignorant and gullible enough to fall for their scams and fakes that that museum curators, auction house objects and seasoned collectors would identify in two seconds.
    I don't know if or how this relates to the book, but thought it interesting.

And most people who buy what are obvious fakes to experts think they are getting a steal from the seller. They think the ignorance-pretending scammers are the rubes who don't realize what the have on their hands and are offering for so much under market value. Counterfeit sales regularly involve greed and deceit from both parties.

Truth is a fleeting glimpse, a second in a thousand hours, a flash from a shard of glass on the ground in the alley that can't be found when you reach the spot, a moment when you're honest with yourself. And even worse it can't be trusted. And how can we find truth when we aren't honest with ourselves?

This book is very much a rebellion and expose against those who find truth in form and bias over substance. And I'm aware that, even when told this, many will still critique the as a work of art.
And there is still an aesthetic structure

* * * *

You can't know everything, so the key is to be an expert on three entirely different narrow subjects-- proverbial pinpoints on the spectrum-- so someone someday overhearing snippets of your conversation in a bar may think you indeed may know everything. I chose ancient numeral systems, late 19th century lithography and The Ropers.

* * * *

I remember when I was a kid, maybe seven, I was reading a kid's book on the couch and the book started saying the words back to me. As I continued reading it got louder and louder and it got so loud I had to shut the book. I told this to my dad and he thought I was joking, a kid's imagination. He also said that's what books do, they tell you stories.

\* \* \* \*

Henry: "Wow, look at you all dressed up. You look like
   Clark Gable."
"Really?"
Henry: "No."

Henry: "It's your own fault asking follow up questions."

\* \* \* \*

One thing as a writer you're not supposed to do is spell things out, telegraph the meaning and summarize the point and philosophy. So naturally, I have to do this. And of course I feel compelled (even aesthetically) to break such rules. It's important.
   And even just there in that above paragraph, spelling out what I am doing, will be considered incorrect form by many literary types.

\* \* \* \*

I had the idea that if you could sing the pitch that perfectly matched a thing's identity-- a tree's, whatever's-- you would know it and shatter the thing.

\* \* \* \*

And I am drinking beer and see dancing sprites outside on the lawn past my window-- and I go out there and make them keep on dancing-- And when they are exhausted and want to quit I make them keep drinking and dancing.

\* \* \* \*

I look outside my window and I want to destroy the snow and bushes, I want to crumple up the gray sky and snow and grass and

throw it away and crumple up and throw it in the trash can and spit on it and stamp on it and destroy it.

\* \* \* \*

With anything I spell out to you, there is more to it. At the very least it could be said in a different way. At the very least it could be said in the same exact way a second time.

\* \* \* \*

And I know if I write and think more, take more notes, I would come up with new ideas, good important ones. But I also know that leaving them out, having them unstumbled upon is more important. An unfinished symphony is the best thing of all.

\* \* \* \*

Yes, one hundred percent definitely this book is in part about how humans, readers, interpret information, find meanings in their biases. And how their judgments of truth and meaning are reflections of their biases. Often their truths are nothing more than their biases.

And, really, many people are only interested in their own biases. They aren't looking for truth in art, they are only looking for art in art. Some search only for beauty but beauty is as shallow as a pretty lying face.

\* \* \* \*

And as a longtime writer who has been trained in conventions, I do have the notion and desire about proper form, content and styles-- which pieces to be left in and which to be taken out, how to balance and shape--, but not only is it okay for me to be imperfect, imperfections are vital. Cutting off the end too soon or too long or too ragged is good. Leaving something essential out or too much in

is good. The meaning is beyond the artfulness (or lack thereof) of the writing.

Orson Welles said 'If you want a happy ending, that depends, of course, on where you stop your story.' And this makes you realize that book form and cropping, ordering, what's left in and out, means so little. That you want a happy ending, that you make a happy story, is neither here nor there as far as the truth goes. The meaning is beyond the book and the good book merely spends its time pointing out its limits.

And if you say the book fails as an artistic work, I say "So?" or even better "Good. Maybe we're getting closer."

But of course I do like art, find power in art, have my favorite works. I play music as I write.

\* \* \* \*

Anyone who asks if this book qualifies as non-fiction is such a superficial person.

I don't know and I don't really care. Category is a checkbox you click when you've finished the book and are submitting the publishing papers.

A freshman geometry book that gives students a theoretical example. Is that fiction or non-fiction and who frigging cares?

\* \* \* \*

Henry in his May West voice: "Come on up and bring some snausages sometime."

\* \* \* \*

Even when I write straight about complex textbook topics, I generally don't like to write one linear attempt at all encompassing text, as I know things are complex and there are different ways to think about things, shades of gray and endless disclaimers and

asterisks. So I offer assorted ideas, snapshots from isolated places, with the expectation that the readier is a student with a brain who knows they are assorted and will try and fill in the blanks, thinks, researches and reads more. This is the only way you can do it with complex subjects.

In most cases I have further thoughts and personal conclusions that I don't express, as I know they're my takes and expect readers to think on their own and know personal commentary from my point of view can ruin things no matter how piercingly correct it is.

In that sense I do intellectually use the aesthetic rules of implying, leaving gaps of information for the reader to make their own thoughts and intellectual imaginations. believe in intellectual juxtapositions and food for thought. The rules of art do apply to my textbook writing.

And when I tell you what is something, why I put it here, what was the point, I leave things out. The explanation is a quick summary or snapshot, and you can never detail everything. And I'm a private person and protect myself.

This is why contradictions are important. When correctly done and honest, they aren't contractions, but point to the whole story, the broader meaning. This is a bit how juxtapositions and collage work

The reasons I can be maddeningly obscure and ambiguous is because the truth is beyond what I can write and what literal minded readers read literally, and the maddeningly obscure and ambiguous points to where it isn't.

The neuroaesthics chapter is an example. This is a topic that leads to so much further and deeper research, thought and ideas, there are so many psychological and philosophical implications that I offer some ideas and examples for the reader run with it. Come back in a month with a paper with your theories and we can discuss.

*strange beauty * cycleback*

If you think that chapter is bare bones, it is. I can add better points to my points, many more ideas and examples.

"Arbitrary social rules are for the week and small minded."
Henry: "I still think you should wear pants to church."

The format of the book-- the way the pieces are arranged on the pages-- is of much thought for me, and there were different possible ways I was going to write this. One way was to have it just straight texts-- no page breaks, no quasi chapters, another was to have a piece on one page with a photo on the other. Another was to have chapters of different formats, including straight, columns, diptychs and triptychs of text and images. The idea and practice of collage and natural juxtapositions are what I like. Of course, I also realize that the format is a contrivance, there is no *real* way to write it and just picking by flipping a coins is a reasonable way. The format is just a way. And, after listening to a script writing friend who went by how the dialogue sounds when spoken, I realize that writing is part visual for me. How the text looks on the pages.
If you say the book should have been written in a different format, I'm not saying your wrong, but I'm not saying you're right.
The breaking of the text with the neuroaesthetics chapter in the middle is just because that was a topic that deserved its own chapter. Chapter-like isolation seemed a sound idea. But it's interesting how it works. It stands out to readers, they will wonder how this format relates to meaning. And it really does in a way (by introduction of idea and physical isolation) change the complexion of the text that follows.
Aleatoricism and the broken glass style of writing is always important to me, as it naturally gives up the ghost of linear reading and reader expectations. But the neuroaesthetics chapter is just in a a place put it. I could have put it at the beginning or end, but people would have used it as as 'template' or conclusion to read the entire text.

Juxtapositions, even just accidental or incidental ones, are things I like.So I am very conscious of format-- and always have designs in my head--, but also know that letting things just happen and leaving things as they came out is good. It has always stuck with me the middle school teacher who said, when in doubt , stick with your initial answer on a multiple choice question

For the record, I'm well aware of all the potential snide reviewers' remarks concerning the title of the books. After lunch at a corner Irish pub named *A Terrible Beauty* I joked to my friend "Well, the name is half right." I was going to say that no matter what I thought of place.

The more I work on a book the more polished and cohesive it gets, so I have to force myself to quit early and no longer touch it. The spell and grammar check is the tool of the Devil. My weaker side uses it behind my back.

You may complain about the mess, but I promise you the final book will be much, much more polished than it should be and poorer not better because of that

I tried to get the pictures-- the squirrel, the baseball card, etc-- each alone on it's own page, but had formatting trouble so decided to mix them in. They're in their current spot in relationship to the text, but each not on its own separate page.

I also had formatting troubles for the neuroaesthetics chapter and decided in the end to leave them where the lay. Any off kilter

formatting isn't tricky for tricky sake, just the way it came out. As Freud said, sometimes a cigar is just a cigar. If he really said that.

"Where's you get those shoes?"
"On amazon."
"What brand are they?"
"I don't know" (looking dow at shoes) "Wait until I take them off."
"What are they? Like running shoes?"
"Walking shoes I guess. Walking shoes I'm pretty sure. Saucany. Actually, they're running shoes I'm pretty sure. It's just when you get all black running shoes they look like something else."
"Comfortable?"
"Yeah, pretty much. I have the tendency to wear shoes over and over until they wear out. Same with jeans. I wear the same jeans all the time until they get holes in them. Usually in the worst parts haha. I once used packaging tapes on the crotch but they made a funny noise when I walked. The key is to wear the correct color underwear just in case. Haha"
"Haha."

\* \* \* \*

Truman Capote said sometimes writing isn't about what the words mean but they music they make. Sometimes when I write, I don't know what is the meaning. The meaning is something else than the literal meaning, what people will read. But I'm not making music either. I felt this when I wrote and looked at 'Sometimes I feel I wasn't made for this world.' There is some truth perhaps, perhaps not, but also an overall foreignness to the whole thing, a distance the words and the act of writing the words.

\* \* \* \*

My brain fights me sometimes, and in different ways.

\* \* \* \*

Memories of college many years ago: I visited my friend who shared a campus house with four guys, and I asked him why the plastic light fixture above the kitchen sink were melted. He said they hadn't done the dishes for a couple of weeks and the dishes had piled up high in the sink, so they decided it was time they did the dishes. He said the pile smelled really bad and was slimy and disgusting, so one of the roommates had the idea to douse the pile of dishes with lighter fluid and burn off some of the slime first.

\* \* \* \*

"I'm not allowed to ask you about your sexuality, but let's say you were stranded on a deserted island with one other person, would you rather that person be person be a woman or a man?"
"Just one, right?"

\* \* \* \*

"Do you have photos?"

\* \* \* \*

Did you know? In real life, Abbot and Costello didn't like each other and often feuded, while Laurel and Hardy were lifelong close friends.
    Also, in real life and despite their on screen personas, Laurel was the smart one and wrote and helped produce their famous short comedies. Hardy was just an actor. Laurel was paid a higher salary by the movie studio, and Hardy was okay with that because he knew his friend did more work.

\* \* \* \*

People define art as being made by people, and not animals or nature, because they want intent and design behind it. Even most agnostics and atheists believe in some form of natural design or order to things.

* * * *

Art itself is a human made up concept.
In the end, a definition of art is subjective and arbitrary.
Does it even matter whether or not something is labeled as art? Does labeling something as art change what it is. Can't a work of art be missing something essential in its very artness?

* * * *

Our definitions and appreciations of art involve our personal philosophies about art and even politics and religion. People see different purposes for art. Some see art as personal expression, others want it to support common social ideals and order. Some people want to be merely entertained, while others like to be challenged. Some are open to new ideas and experiences, while others judge art by how it reinforces their preconceived philosophies. Some require historical and factual accuracy in a movie, while other appreciate that facts are sometimes fudged for aesthetic purposes.

Art and aesthetics are often used for social order. Dictators have glorifying statues and murals and set laws for what is acceptable art. Religions use art to promote their beliefs. Artists who deviate from the aesthetic rules are often deemed as rebels and dangerous. Abstract and other modern art has often been labeled as degenerate by the powers that be. Society pressures people to dress and style their hair in certain ways. People willingly dress to belong to or rebel against groups. How you dress says a lot about what you believe.

Religious beliefs influence artistic form. In early Christian culture, the importance was given to the afterlife not life on earth. A result was the early Christian art was not realistic. On the other hand, early Chinese religions were centered on nature and the early Chinese art had much more focus on and realistic depictions of nature. By Islamic belief, artwork is flawed compared to the work

of God. It is thought that attempting to depict the realistic form of an animal or person is religious heresy. Thus Islamic art often lacks realistic humans and other animals, and is noted instead for its intricate and elaborate patterns and designs.

\* \* \* \*

It doesn't matter what you think is, it matters what is.

\* \* \* \*

A friend said I write as if I'm not human. I took that as the best review yet. Though she then said she meant it because she thought I wrote dispassionately, free from human emotion, which I thought curious because I thought that untrue.

\* \* \* \*

Henry: "The key to being a successful businessman is to in your money back guarantee misspell money and guarantee."
Henry: "And 'back' to be safe."
Henry: "'Technically, sir, if you read the contract, it says if you don't like the product I get to moon you.'"

\* \* \* \*

multi-media? Add music with entering music?

\* \* \* \*

The funny thing is even when the reader acknowledges and appreciates the philosophy of discord, he will still judge the discordant work by its attractiveness. Is it good looking ugliness?

\* \* \* \*

"You're one of those ivory tower types, aren't you?"
"Actually, it's a second story apartment."

\* \* \* \*

For those trying to find the meaning in my work, I work on the expectation that you've read everything I've written, have yet to write, won't have time in my life to write. I'll write out rushed outlines near the end like Sade.

And my writing doesn't tell many secrets, even my favorite sit com, football team and food. I think my personality and knowing my favorite pop and fruit are an essential part of understanding my philosophy.

\* \* \* \*

"What the hell is that?"
"It's a dog. A dachshund chihuahua mix."
"Oh. Okay. As long as it's on a leash."

\* \* \* \*

With all their photoshopping and lighting, rules for imagery and books and movies and furniture arranging, I realize humans are trying to reach a harmony or unity in their lives. Some sort of psychological, metaphysical, spiritual harmony or perfection in the complicated world. Even when the attempts are half baked even by their own standard, or forgotten for a while or suppressed for practical reasons, this is what deep inside they are striving for.

And they often know they can only approach it in a small picture framed on a wall, the way they shoot and photoshop a photo. You can see the attempts in the way they criticize this book,

sometimes in the shoes they wear. To most people, perfection involves personal controlling.

And I too am trying to achieve it, move towards it through my disorder. My disorder is a breaking down of false order in order to build something new. It's a breaking down and a creating at the same time. But the real creation is for another book. Going against aesthetics norms is an aesthetic practice.

There is a book I have been planning on writing for years that will lay down my aesthetic castle. It has been put aside for years, even forgotten and dismissed for long periods. I know exactly how it ends and many of the the scenes have been composed in my head for years. It ends in a wet dark purplish red.

\* \* \* \*

And after I reject and mock and roll my eyes at those who judge this book via aesthetics, taste, who give it a thumbs up or down because of aesthetics, and talk how I obscure and hide information, people will say that art is a form of communication between people and I say that's the problem-- it's a human thing, a two people thing, a lowest common denominator-- when truth is not in that, truth is outside of that. Truth is outside of this book and outside of people and certainly outside of you and your artistic taste.

\* \* \* \*

I'm looking for truth not art, though I realize neither of us it will find it. Though my truth is that we won't find it.

And of course I'm looking for art too.

\* \* \* \*

I listen to a pop song on the radio and it breaks my heart

and of course the main question is, considering we don't know can't know, how can we act what should we do ... How should governments be set up knowing there is no true way of doing things, and no specific answer of what is the right goal and how to gain it

So ultimately the search for truth can change, switch, to fiction and falsehood and self deception and mass deception-- as we cannot function without these

\* \* \* \*

And, though I don't attempt to prove it or claim it as as universal truth, I do believing in goodness and being nice to others and being honest and not stealing. I do believe in happiness.

And of course, when the focus is on utility and practical success and how to run this well on this earth you get into lies and conceits and arbitrary rules and fooling yourself-- you must move away from truth to function.
    I won't go into this-- it's psychology 101, --, because I've covered this in other books. Return Trip or Conceits for example. I swear I'm not spamming my other books, I just don't think I should rewrite what I've rewritten five times before. I'm trying to beat my habit of beating dead horses. Trust me that it's correct, because it is.

\* \* \* \*

the general deal with this book I'm, in part, ,looking at how humans process information using their aesthetic and other biases. One thing I don't intend to do is to cater to their biases, and my intention is not to create a perse aesthetically pleasing work. This is why I say that

someone who judges the work by their perceptions and expectations of beauty and form is doing it wrong.

On the other hand, I pick out the pieces, am not oblivious to communication. I have my own aesthetic taste and find the order of this book pleasing

Even stating all this here goes against the normal literary game. I've explained too much about what is going on.

]
Explicitly and clearly tell philosophy of world and art

Not true. I never called you my charity case. I called you penance.

Conversation between my mom and her friend over my mom's proposed sour cream container invention:

Mom's friend: "Ask your husband to make it. He's an engineer."

My Mom: "He's a a chemical engineer not a mechanical engineer.
   He can only poison or blow up things."

What's the philosophy? Point.
It's a lot of things. It's about the impossibleness of human expressing and knowing the truth, how attempts to through art are doomed. It is a fight against art, against false aesthetic ways of looking at things. It is a look at the philosophy of art. It the author's own struggle to create something, create a work. It is about the author's own psychology and personality, because personal psychology can't be escaped. It's against the artistic reading of things. It's a mad scientist trying for everything (editorial note: this is unrealized, from first draft outline. Not developed in this book). It' definitely is a rebellion against aesthetic norms.

I do write in collage (editorial note: this more applies to a different version), but most of the stylistic labels I have for my writing are made retrospectively, rather than thought of and applied foreword. Though many years ago,I liked how Eric Hoffer and Kurt Vonnegut

wrote in little pieces, skipping the useless connecting filler. And I liked a lot Celine's ellipses in *Journey to the End of the Night* and mimicked it when I was young and typical, but don't use the ellipses style anymore.

I'm a skeptic, but also believe that if a placebo works a placebo works.

Anyone who gives you the 'real,' 'absolute' definition of art and points out which works on the wall are and are not the 'real' works of art is full of it and probably an overbearing know-it-all in general.

I strive for this book to be an artifact more than a work of art.

"I'm lost."
Reverend: "That's why you're here, my son."
"No, I mean I can't find the bathroom. I was told it was down this hallway."
Reverend: "Over there."

"What do you think of Mozart?"
"Uh, he's too frilly for me. Light and frilly."
"I agree."
"Actually, we sometimes play him in recorder group and playing him you can tell how talented he is. You can tell when you play them. We've also played his dad and Solieri- the guy from Amadeus- and playing them you can tell they aren't as good."
"Interesting. Who's your favorite to play?"
"Hmm. Maybe Bach. Maybe Beethoven. I like Handel to listen to, he's one of my favorites, but he's boring to play."

"Who's the hardest to play?"
"I don't know. I'm not the most talented player, so I'm perhaps not the best to judge. Ha ha."
"Everything's hard."
"Haha. Yeah I guess. I dunno. I once tried warming up my recorded by the fire and it melted all this like waxy varnish on it and covered the holes."
"Haha."
"To be slightly off topic. Actually, I can read music but don't know the notes by name. Letter. So if someone says "Play a G' I have to have them point to the note on the music sheet."

"Oh. It looked like you were taking piano lessons in the photo."
"Uhhh. What?"
"I don't know. With the curtains and the computer on the desk. It looked like a piano."
"Hmm. Hahah. Okaaaay."
"Call me crazy. Haha."
"Have you had lunch yet?"
"Uh. Not officially, but I had some bread and almonds before. Unofficially. I'm not that hungry, but will eat if you pay."
"I was going to Taco Gayaneros if you want to come."
"Sounds good. I'm suddenly hungry. Burritos Son Latondos."
"What?"
"Nothing. You ready to go?"

\* \* \* \*

The spelling, punctuation and similar errors weren't intentionally put in, just intentionally left in. But I'm not suggesting I'm perfect and in complete controle, I'm sure some came and went unnoticed. I won't take credit for every error.

I suspect many already assumed those errors were noticed by me, and this begs the question of it is even necessary for me to point out

them being intentional It probably isn't required, and may even ruin the literary effect of spelling out things. I already talked about people disliking meaning being telegraphed and jokes having to be explained. Though this aesthetic predilection is one reason why I chose to keep in this part. If it was purely an aesthetic, literary reason, I would have cut out this last part. Something that goes against your aesthetic grain often also go against mine-- and I leave things as written specifically because I am questioning the grain, because going against the grain is good.

For the record, most of the book was proofed and spell checked, but some areas I left as is for various reasons.

I really couldn't have (and wouldn't have) wanted a completely unproofed book, but also definitely didn't want the book seemless pearl perfect. Perfect spelling, grammar and style would have gone against everything

In proofing I notice some errors that changed the meaning. Forgetting the 'ir' in irrational and forgetting a 'non.' I figured I'd better fix those, though the idea of having the very meaning reversed was intriguing.

I promised I fixed all the meaning errors I found, though did leave a few areas of linguistic muddiness. .

Hand signing a print is a relatively recent thing, starting in the late 1800s. Original Rembrandt and Albrecht Durer prints are not hand signed. Durer prints often have his machine printed monogram as part of the printed graphics.

In modern times, the artist's hand signature on an original print shows that the print was personally approved as finished by the artist. The artist signs it when it's all finished and meets his or her approval. Prints that didn't come out right go unsigned and are often literally destroyed and tossed in the trash. This explains why art collectors pay more for a hand signed original print by a famous artist. The extra price is not just because it's autographed, but

because the autographed indicates the print was personally okayed by the artist.

"Are you going to write a second novel?"
"No, I'm too damaged."

1.   Henry: "The two greatest inventions in history were aspirin and women's yoga pants."
"Hard to argue with you there. Though I'd add air conditioning."

\* \* \* \*

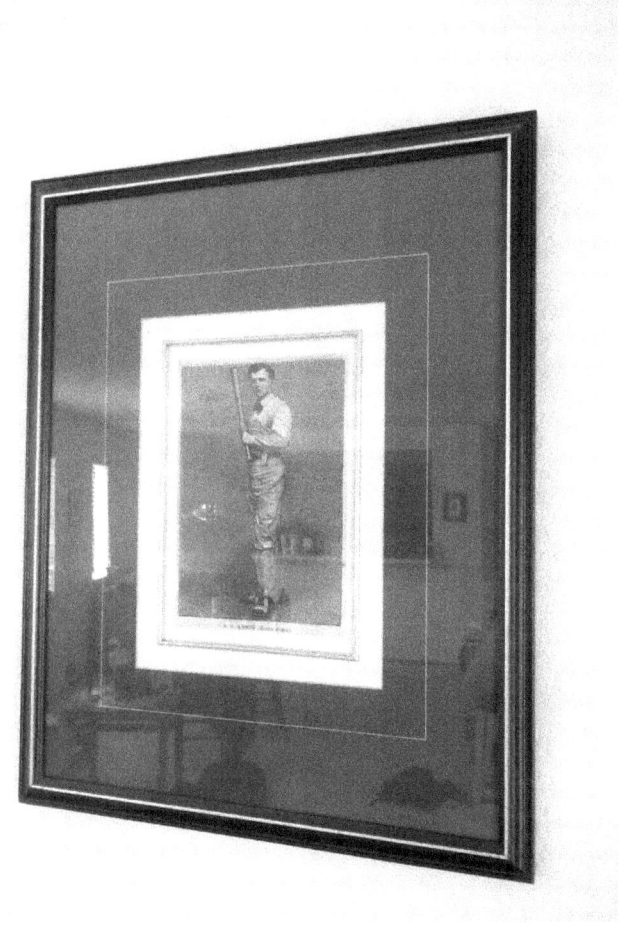

**About the author**

David Cycleback is an art and artifact historian and philosopher and an internationally known authentication expert. His was a two-time Eric Award Finalist for his books *Return Trip* and *Conceits*. Reprinted by Bejing's Three Shadows Art Center, his guides *Judging the Authenticity of Prints by the Masters* and *Judging the Authenticity of Photographs* were the first comprehensive books on the subjects published in China. He has advised and examined material for major auction houses and institutions, was a writer for the standard academic reference Encyclopedia of Nineteenth Century of Photography and writes an authentication advice column for Sports Collectors Daily. His other books include A*rt Perception, Looking at Art and Artifacts, A Brief Guide to Ancient Counting Systems for Non-Mathematicians, Forensic Light: A Beginner's Guide* and *In Pieces.*

www.ingramcontent.com/pod-product-compliance
Lightning Source LLC
Chambersburg PA
CBHW072237170526
45158CB00002BA/939